UNDERSTAND HOW TO DRAW DS1
Basic Drawing Techniques

Clifford Bayly

SEARCH PRESS

Wellwood North Farm Road Tunbridge Wells

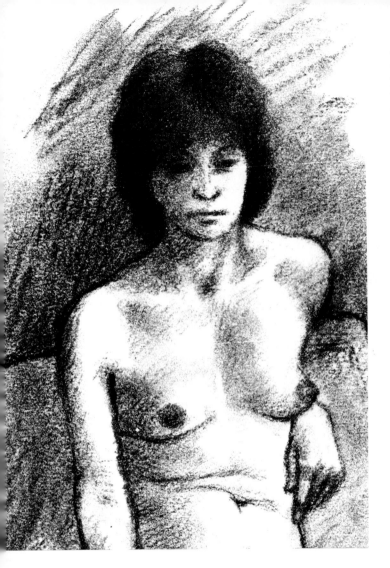

Introduction

Drawing is a universal language. Prehistorically and in its simplest form it delineated our basic symbols and from these our various written languages and systems of visual communication have developed. In spite of this sophistication, drawn images still hold a strong fascination for most of us. It is essential that we nurture these drawing skills and disciplines, for the activity of drawing can offer considerable enjoyment both to the onlooker and the artist. Like all other forms of self-expression, drawing has been developed to amazing degrees of competence and emotional intensity. However, this in no way diminishes the pleasure of returning to basic principles and of practising the huge variety of techniques, and experimenting with materials, that are available today.

This book aims to help and encourage the reader, by the process of trial and error, to develop his or her own objectives in the very broad field of drawing. One may find that realistic rendering of objects in light and shade (illusionary drawing) is what you wish to pursue. On the other hand, you may well find that this approach is not in tune with your interests or abilities, and possibly you would be happier working in a more decorative two-dimensional style. In this book I shall offer many alternative approaches to drawing but you will, of course, through experiment and experience, arrive at your own evaluation of which forms best relate to your attitude and personality.

To those of you who wish to further your abilities in delineating accurately what one sees, this book will offer a chance to develop this skill whilst offering others the opportunity for more expressive and personal experiment. For the former, perspective, structure, scale, lighting and tone are important areas of study; while for those less interested in optical accuracy there are sections dealing with the physical qualities of paper, drawing, media and methods of producing interesting and exciting graphic effects.

Whatever area of drawing interests you most, remember it is a form of personal expression and will contain its own significance. If you enjoy the experience of drawing this will inevitably show through and your work will contain its own unique quality. I mention this to encourage specifically those readers whose background experience of drawing may have been rather rigid and narrow and who consequently find difficulty in coping with the wider interpretations of the term 'drawing' that this book aims to demonstrate.

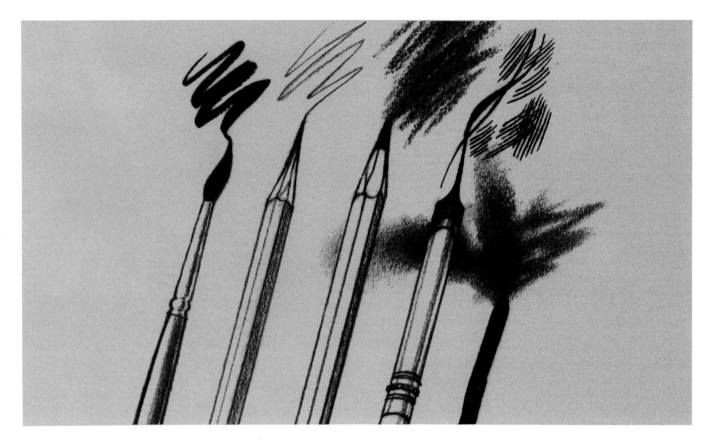

Materials and Organisation

Unless you are making quick on the spot drawings when the main object is to record as quickly as possible the subjects that catch your attention it is best to be as comfortable as possible. A flat table is the most convenient surface on which to place your paper, but a tilted drawing board will allow your drawing tool to move over your drawing surface without your having to stretch. Arrange yourself so that any shadows caused by your drawing hand fall away from the point of contact of your drawing tool and you can see the strength of line or tone clearly.

You can draw with anything from a simple stick of charred wood to the sophistication of computer graphics! Your choice of medium should be dictated, however, by the type of drawing you intend to produce and the purpose for which it is being made. Because of the enormous range of materials on the market it is essential to appreciate their inherent qualities and respective characteristics.

Charcoal. A medium to coarse surface paper will give best results. Charcoal smudges easily, so take care; yet this is its essential characteristic and should be utilised whenever possible.

Chalk includes pastels, soft or hard; pastels are made by compressing powdered pigment with chalk to control the softness or hardness. Light chalk/pastel can be used very effectively to highlight charcoal drawings.

Conté crayons (a special form of hard pastel) come in a limited range of black, brown, sanguine and white.

Pencils range widely from very soft (7B) to very hard (6H). Special pencils are also made, such as carbon and conté pencils in several grades. These are useful for

good blacks but they smudge more readily. Clutch pencils, which grip a separate lead element, can be useful where it is impracticable to keep sharpening a wood pencil.

Crayon covers a variety of composite materials, either in sticks with paper wrappers such as wax crayons or in special compositions of pigment and binding agents contained within a pencil format. Watercolour pencils fall into this category.

Pens. The most basic form can be a sharpened stick. It produces an informal quality — blobby, but useful in landscape and strong textural drawings. Quills, steel nibs, fountain pens and special drawing pens are all developed from this basic principle. The ballpoint can be most useful when one needs to make notes unexpectedly and it can give good results when clear specific, descriptive drawing is required. However the line is rather characterless.

Felt-tip pens and markers come in black and many colours, water soluble or water resistant. They have their uses, but avoid using them indiscriminately until you develop sufficient confidence to decide for yourself their advantages and disadvantages.

Brushes. It is possible to draw with the brush. Drawings can be supplemented most effectively by adding washes and texture.

Inks. For pen or brush work it is advisable to use soluble inks or watercolour. Black fountain pen ink is very useful. Manuscript ink — black and sepia — are especially formulated not to clog the lettering nibs or quill, and are very good for drawing. Chinese stick ink gives beautiful greys and soft black; dissolve the solid ink stick by rubbing it into a saucer or other shallow palette. Waterproof inks, once dry, can take watercolour washes over them. When you wish to thin inks, use distilled water or rain water. Tap water can cause many inks to curdle and many watercolour inks fade rapidly.

Other materials. A fixing agent may be necessary when using charcoal, carbon, conté crayon or pastel. The most convenient system for applying this is by aerosol spray. If you have to use an eraser, plastic erasers are best as they stay cleaner. Putty rubber is especially useful for erasing charcoal. Do not rely on erasers, however; draw without them whenever possible unless you deliberately lay a tone and wish to pick out highlights in it.

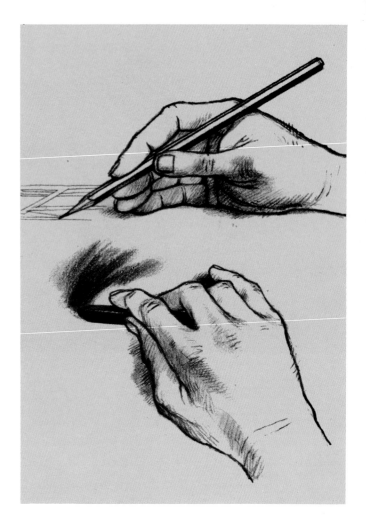

Two ways of holding drawing instruments are shown above. The one which comes easily to most people is how they grip a pen when writing. The other depends on moving the whole arm — most professional artists employ it, because it allows one to make marks in any direction with more ease and eventual control.

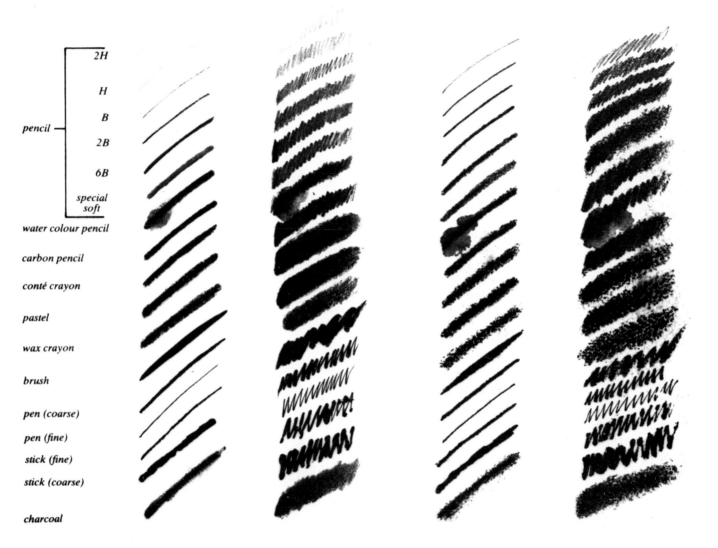

2H

H

B

2B

6B

special soft

pencil

water colour pencil

carbon pencil

conté crayon

pastel

wax crayon

brush

pen (coarse)

pen (fine)

stick (fine)

stick (coarse)

charcoal

The various marks made by many of the media mentioned in the text. The two bands on the left were made on smooth paper; the two on the right on rough-surfaced watercolour paper.

Papers and surfaces

Bleached rag provides the best modern quality papers; esparto (grass) and wood pulp are used for the less expensive to the cheapest. Papers can be hard, soft, rough, smooth, white or coloured: from the thickness of stiff board to the flimsiest of tissues. Do not be put off by the range available — most artists record their thoughts on whatever is handy, unless they are working on a considered drawing. Try drawing on sketching paper or on a layout pad — even a lined exercise book is better than no paper at all. Most important, always have drawing paper available (together with a drawing instrument) at home, or in your pocket or bag when you are out of the house.

The drawings on these pages demonstrate the use of various papers in relation to the drawings on their surface. For the drawing of a seated girl I chose a smooth cartridge over which I drew in medium width felt pen. This enabled me to work very fast, giving a strong clean line and areas of dark by blocking in on her hair.

The nude, on a slightly rougher cartridge (below) drawn in 2B pencil, enabled me to catch the soft skin tones in a soft light. The cottage (page 7, top left) was drawn on rough watercolour paper with a 6B pencil; while black sugar paper was the support for the drawing of apples on a plate, which was done in white conté. White conté was also used for the drawing of the pot plant on light brown Ingres paper (far right). Note the texture differences between these last two drawings, which is imparted by the paper grain.

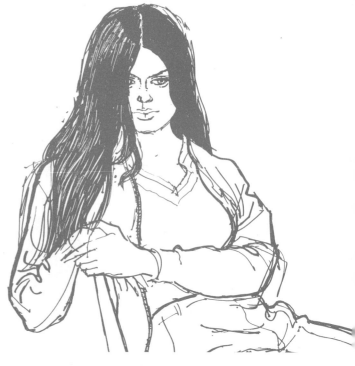

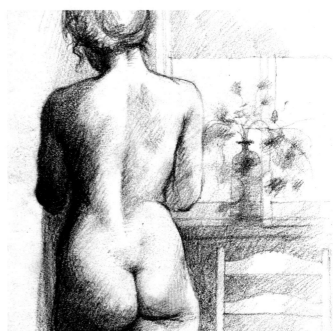

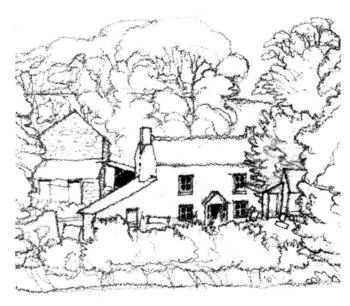

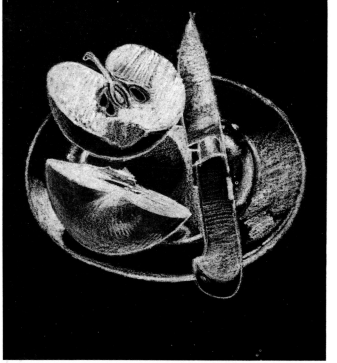

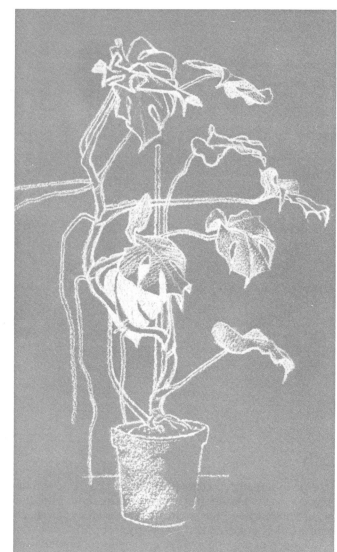

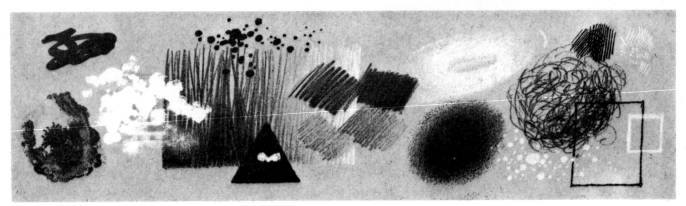

Marks

We have already discussed materials. Let us now look more closely at the marks they make and into the possibilities these offer us to record visual experiences and express our reactions to the subject.

We need to develop a broad knowledge of how to produce these marks and be aware of their individual qualities so that we can use them skilfully — in short to be technically as well as visually in control of our work. A line is a mark — so too are fingerprints, a smear, spots and droplets, blots and scratches — all of these can play a valuable part in drawing. In fact all marks are useful, but only when they are appropriate to what is being expressed in the drawing. In isolation they are meaningless.

Do not become preoccupied with the quality of marks for their own sake. It is possible to produce decorative effects that are attractive (as in some forms of illustration) but of little use if they do not carry useful information or express the subject satisfactorily. The way marks are applied to the paper tends to reflect the attitude of the artist. Broad strong direct strokes reflect confidence and an interest in the basic qualities and mood of the subject; fine precise line work might show an intensity of interest in structure and detail.

Just as the artist's *subjective* attitude to his subject is reflected in the quality of the marks made, so we have to make a conscious *objective* effort to use appropriate marks related to the subject-matter we are portraying. If

8

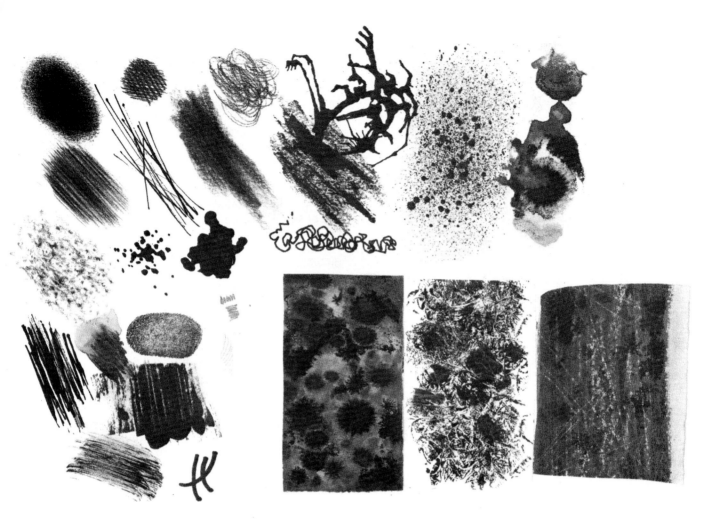

we rely entirely on marks we are likely to neglect the concepts of form and structure. These must be present simultaneously in our drawings, otherwise they will appear flat and formless. Decorative and illustrative work can exist in a two-dimensional form, but if you are hoping to represent three-dimensional forms and distance then some structural drawing is essential.

Blots, dabbings, fingerprint drawings, scribbles, hatchings, rag dabbings, scratchings, white and black marks on grey paper — all these are illustrated on these two pages.

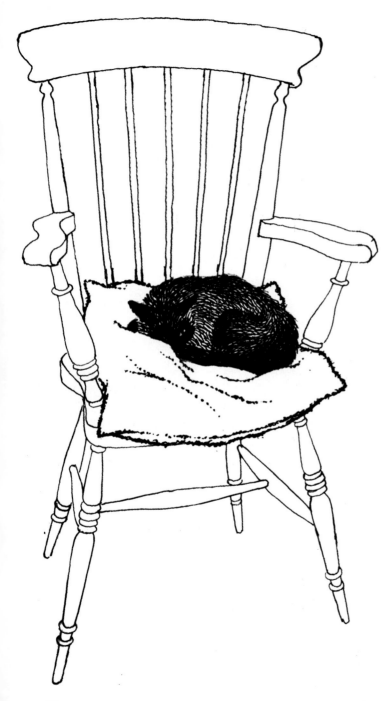

The linear aspect

The most commonly used and expressive mark in drawing is the line. A silhouette describes the boundary between light and dark without reference to form, yet it gives us basic information about that boundary. Extend the picture further by drawing in edges within the silhouette and more information is revealed. Such drawing can be referred to as objective. As a simple exercise in the expressive power of line, draw one object in front of another in lines of equal weight. Now go over the lines of the object in front, making them darker or stronger or both — and immediately it will appear nearer, even if the object is smaller. This is a simple demonstration of the expressive power of lines.

Structural line drawing can be learned; it has little to do with talent or depth of expressive feeling. Using lines to give an impression of solidity and space is a matter of careful observation related to a few basic rules and optical laws. They can be learned quite easily. Once you have acquired the skill of 'structural' drawing start to use line to express feeling and movement. An expressive line can be straight or flowing, scribbly or jagged, continuous or broken. It can describe form by following it rhythmically, it can express tone by cross-hatching, it can portray stillness or movement through its dynamic quality. Within a single stroke it can become thick and thin, heavy or light.

On pages 10, 11 and 12 you will find several instances of observational, expressive and dynamic line, sometimes in combination, but all demonstrating different varieties of use.

Left. *Observational pen and ink drawing using three qualities of line — pure outline, jagged line to express the texture of the cushion, heavy cross-hatched and contoured short lines to depict the cat.*

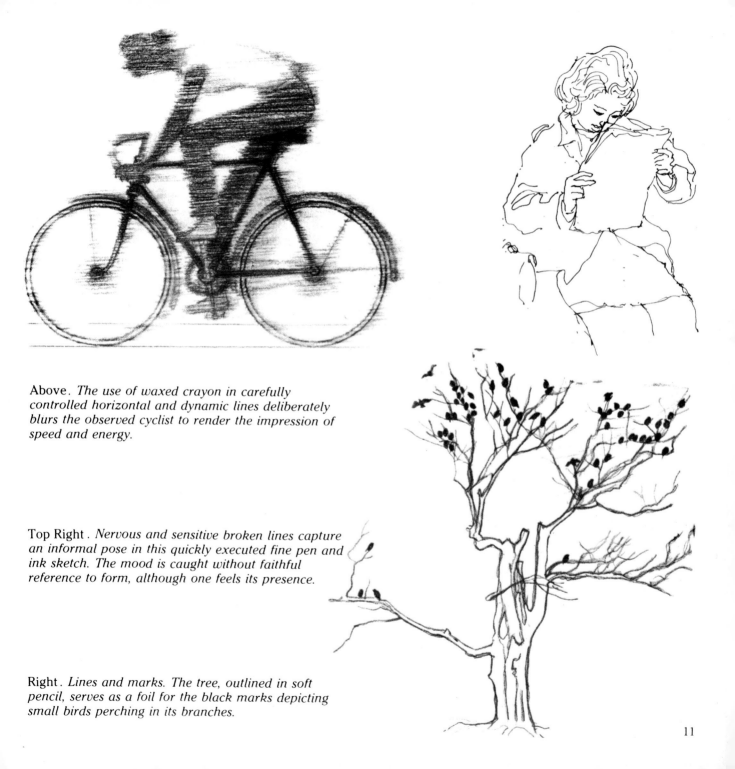

Above. *The use of waxed crayon in carefully controlled horizontal and dynamic lines deliberately blurs the observed cyclist to render the impression of speed and energy.*

Top Right. *Nervous and sensitive broken lines capture an informal pose in this quickly executed fine pen and ink sketch. The mood is caught without faithful reference to form, although one feels its presence.*

Right. *Lines and marks. The tree, outlined in soft pencil, serves as a foil for the black marks depicting small birds perching in its branches.*

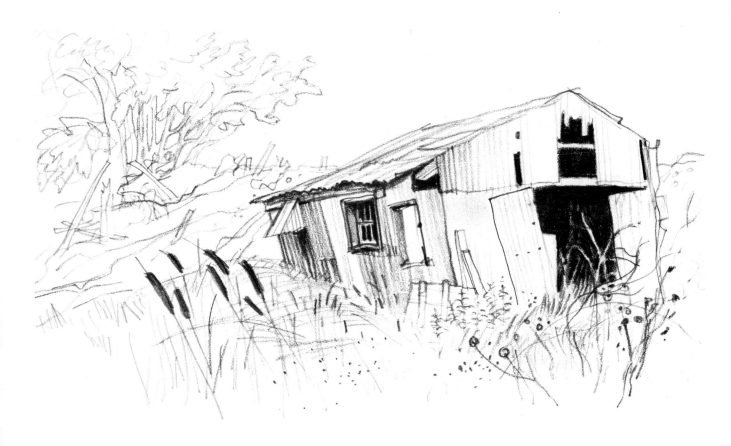

Above. *Essentially a linear drawing, this study of a derelict shed in soft pencil contrasts free-flowing lines in the trees and grasses in the foreground with the geometric forms making up the shed. Tone is added sparingly to emphasise the abandoned nature of the subject.*

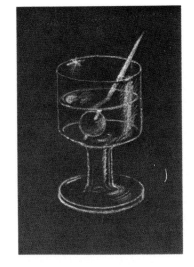

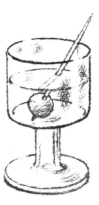

Right. *Two studies of a glass, one on black sugar paper, the other on white paper. A black line on white has a totally different quality from that of a white line upon black. Experiment by drawing the same subject in totally different media on contrasting papers.*

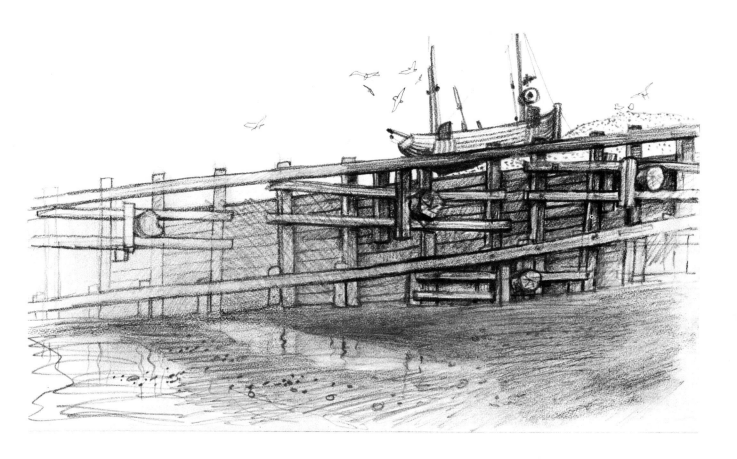

Tone

We have seen how line can build up our pictures. By adding tone we can create still further the illusion of three-dimensional form or enhance the mood and atmosphere. Tone is essentially the study and application of lights and darks. As we view our subjects in colour, and under differing lighting conditions, we must make a mental adjustment when depicting tone — transforming the qualities of light, colour and texture into a variety of darks and lights, and observing within them highlight and shadow. If this seems confusing, look at your subject with your eyes screwed up — this reduces the effect of colour and detail, yet one can still see the basic tones.

Another word for tone is shading. You can apply tone to a drawing by cross-hatching by continuous tone in dry

Above. *Compare this drawing with the derelict shed opposite. Here the construction is mainly tonal; I have increased the darks towards the central subject, the boat on the slipway, and smudged with my finger the areas of mud beneath it. This was mainly done in soft pencil; the attendant seagulls were drawn in with a harder pencil.*

or wet medium, or both. Tone can be hard or soft, smooth or coarse. Within tone one can, by the way it is applied, describe textures — soft cat's fur, the naked shoulder of a woman, shiny leaves, the woven straw of a hat, or rusty metal.

The paper you choose will, however, have a significant effect on your drawing. Unless you are laying down washes of thinned ink to achieve tone, the grain or smoothness of the paper will reflect the mark you make upon it (see the sections on Materials, and Marks).

There are practical problems to be faced when you are working with tone. First, with dry media, there is the tendency for most of these to smudge. This should be seen, however, as a quality of these media which can be creatively exploited in your work. However there are situations when it is necessary to keep the surrounding paper clean and confine the rich smudging and softened tone to very limited areas. Basically, this is achieved by simple common sense in using your media, such as working from left to right (if you are right-handed) and keeping any completed work under a cover of light smooth paper held in place temporarily with tabs of masking tape. Your experiments with various media on different papers, as suggested earlier, should now begin to relate directly to your developing drawing abilities. The samples of drawn objects here show how appropriate media can not only help to suggest the character of the subject but have been drawn on the appropriate paper surface. For example, the pulley wheel block — while drawn with a fairly hard pencil (HB) so that the wood grain and smaller forms of the copper rivets can be represented satisfactorily — is drawn on a smooth hard cartridge paper. A rough-surfaced paper would destroy any fine work, however carefully drawn even with a well-sharpened pencil.

Of course tone can be used to express mood, mainly in landscape subjects but also in drawings of interiors and in some figure work. Avoid attempting to cover large areas of the drawing, such as sky or water, with continuous tone. It is likely to make the work look heavy and dull and will tend to smudge and pull down the rest of the work.

Small areas of tone in carefully selected areas work best with strong emphasis only in the deepest shadow. Practise a series of small tonal landscape drawings of a simple subject but try changing the tonal pattern in each. For instance, in one the sky could be light and the landmass middle-grey with small dark objects in the foreground; while another could have a middle-grey sky with a light landmass and dark foreground objects — variations ad infinitum.

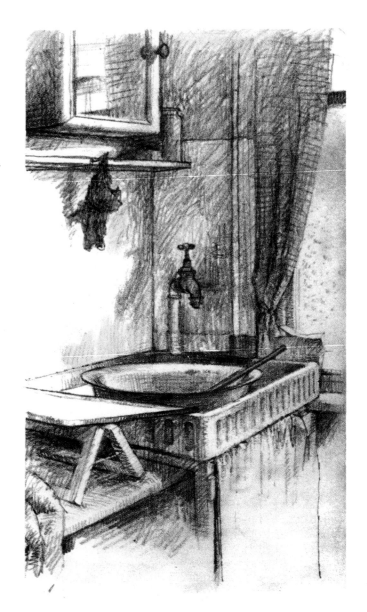

Above. *A study of a kitchen sink in a cottage demonstrates how tone can enliven even the most banal subject. The subject was first drawn in hard pencil; then, with a soft pencil, the tones were added loosely and, in places, smudged with the finger.*

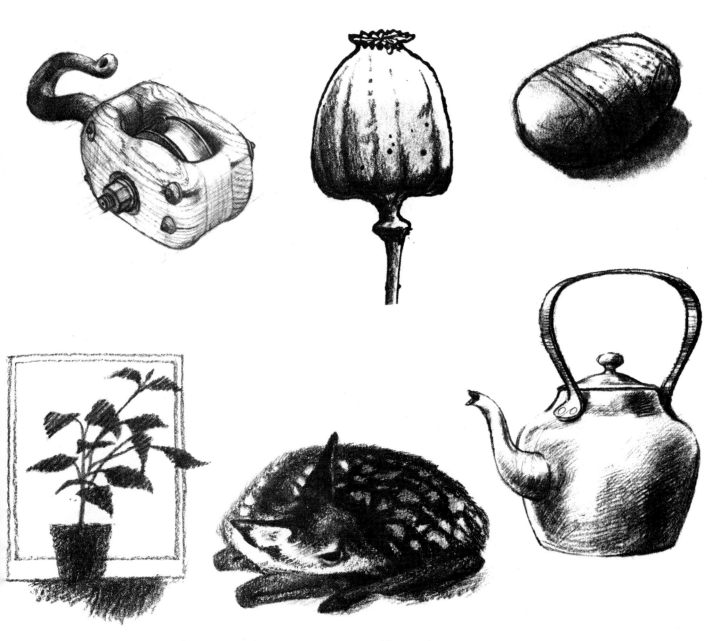

Above. *An assortment of views, objects and observations. Notice how each drawing has its opposite texture for wood, material, stone, plant, fur and metal.*

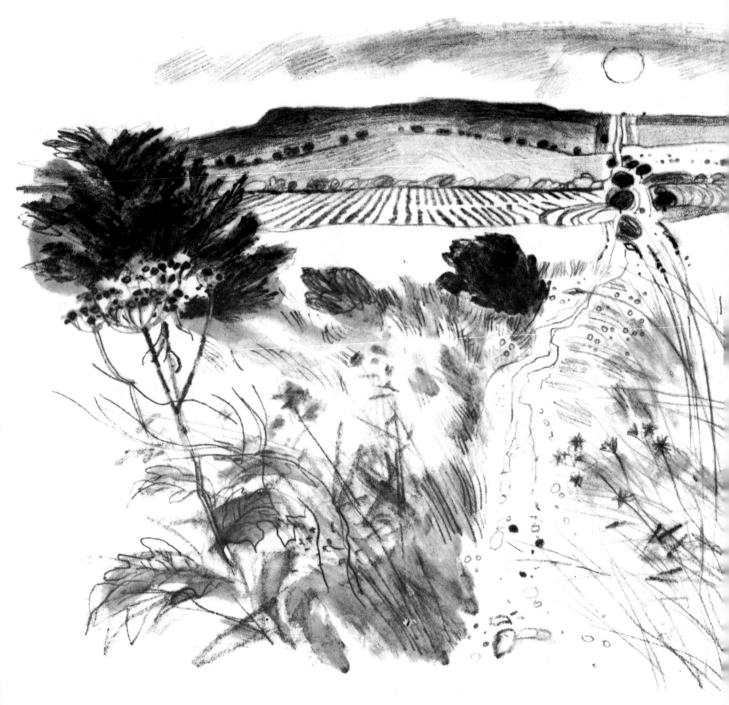

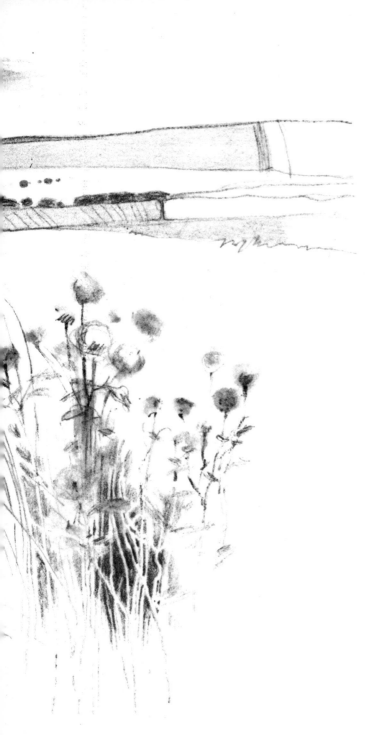

You will find evidence of the application of the basic aspects of drawing dealt with in this book, from making marks using differing media to the use of light, tone and texture. In producing this sketch I was preparing for a large painting to be produced later in the studio. It required reference on tone and particularly texture. While working I was continuously discovering dynamic forms of contrast: linear forms against solid masses; small dark seed heads against soft areas of light grass; dark masses of bushes against light and strongly textured fields; small areas of detail set amongst open blank spaces. To do justice to the richness of this landscape I used pencils: H.B. for fine lines; 3B for heavier shading; black watercolour pencil for dark masses and wash areas — plus a liberal use of the thumb to soften lines and unify areas.

Note the dynamic reversal of tones and line work in the counter-change of grass stalks — from dark stems on light background to light on a dark area. This gives richness and interest to comparatively simple material.

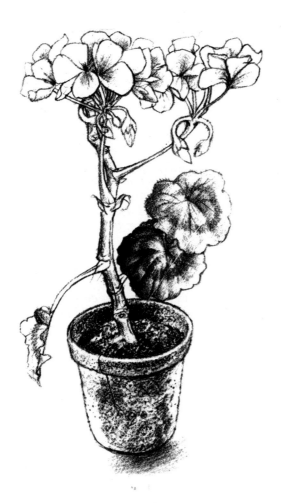

Composition 1

To illustrate form and structure in drawing I have taken a simple still-life group using very basic forms. In the illustrations opposite you will see several views of the same group. It is important to develop a natural sense of form and space through careful and mobile observation. To this end try setting up a similar group and then make simple drawn records of it from as many angles as possible.

A word about ellipses. Remember when drawing these that the widest distance across the ellipse will always be at right angles to the axis down the centre of the round object itself. You can check this both by direct observation and by studying these drawings, where I have left the structural lines showing in several instances. It is useful when making your own basic drawings to set up these construction lines right from the start and leave them in for continuous checking purposes.

Once we have established the edges of the forms we are drawing, we have to consider how light can emphasise the solidity of the objects or detract from them simply by the angle at which it falls on the subject or the angle from which we choose to draw it. I mention this because, although we are at liberty to change our angle of view, we may not be in a position to change the angle of the light.

Above. *Geranium in a pot. This drawing shows how effectively the use of two different media can provide contrasts in texture. The plant was drawn in soft pencil, as was the outline of the pot, whose rough-grained texture was drawn in later with black crayon.*

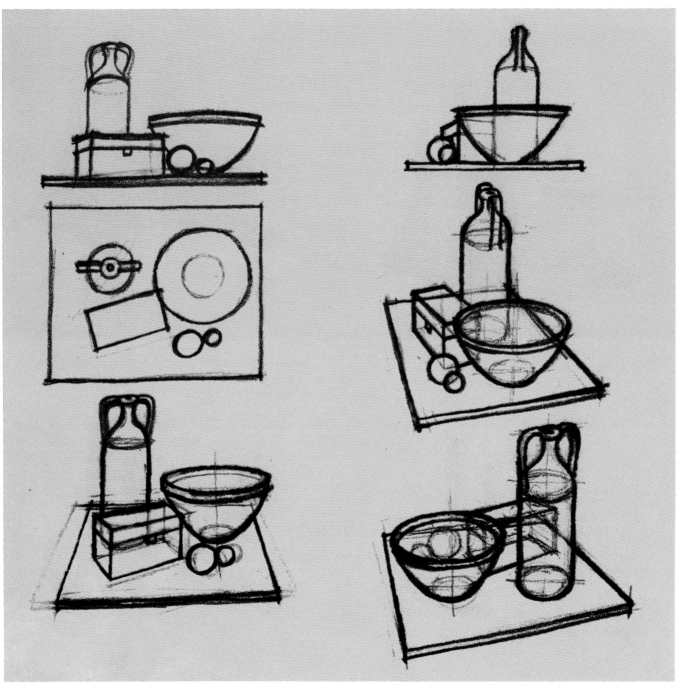

19

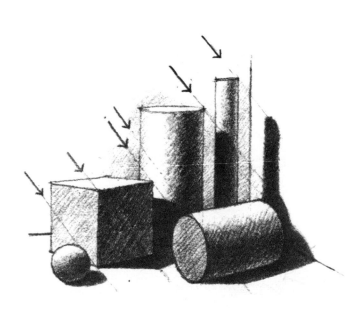

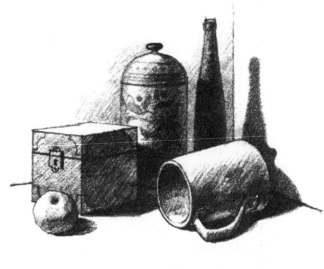

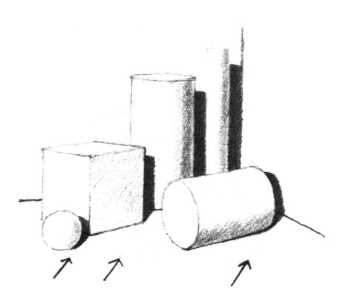

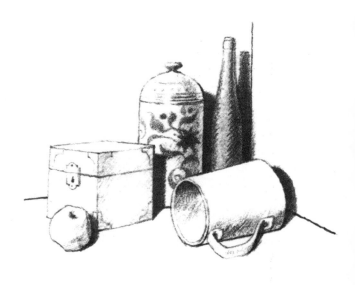

20

Lighting the subject

Light plays as important part in any composition. Study the way the light falls on any group of household objects and notice how the shadows can aid or detract from the composition, confusing or binding the shapes. Try to see the shadows as well as the objects — do they define or complement the overall subject, or confuse it?

In the illustrations on page 20 are two pairs of drawings. In the top pair the light is falling from the top left, creating unlit surfaces and distinct shadows, some of which fall on to other objects in the group thus defining their shapes more distinctly.

By way of contrast, the lower pair of drawings is lit from the front, which flattens the modelling, detracting from the overall unity of the group, so that the objects within it seem disparate and unconnected.

These two examples demonstrate how important it is to study every aspect of the subject you wish to portray. Where it is possible to rearrange it, do so, for by so doing you will learn more thoroughly the elementary rules of good composition. Practise with a few contrasting shapes — bottles, cereal packets, fruit, mugs — on a table pushed into a corner of the room, and shine a portable lamp on them from different angles. Without lines, just shade in the tones and you will soon see what gives you the most satisfactory composition.

Stalking the subject

Below are four drawings of the same subject viewed from different angles. All are satisfactory — a simple demonstration that there are many ways of viewing the same group. Walk around your group *before* you start drawing, try looking at it from different heights and angles — in this way you will find the aspect that pleases you the most.

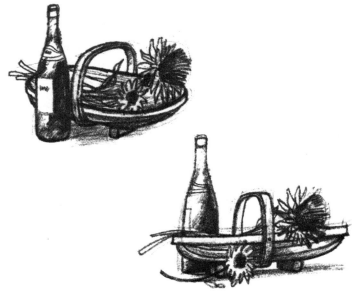

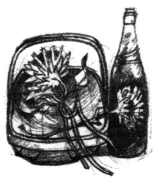

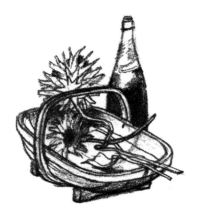

Composition 2

The way we place our possessions about our houses is often an expression of our personality — so what better subject could we have, or one more familiar, than the interior of one of our own rooms? But, as you begin walking round your living room or bedroom, you will begin to notice how perspective controls or even dominates what you see — with apparently converging lines where ceilings join walls, where the lines of door-frames echo them, where the squared edges of tables 'angle off' to a vanishing point. Here, I am more concerned to show how, by moving about a room that is sparsely furnished and decorated, light from a single source, window or artificial, can determine your choice of viewpoint.

As in the demonstrations on still life, I give a room plan with a few pieces of furniture. The 'eyes' show the two viewpoints I have selected. The two drawings below the plan show in outline what I see: a view from a standing position behind the table looking towards the window, the other from a sitting position looking across the room.

On page 23 I have drawn three tonal studies of these views: the top picture indicates the light source as coming from the window, the one below it the same view by artificial light from the pendant light at night time. The same viewpoint — but how different the two pictures are in composition! The relative tones of walls, objects and shadows are completely changed although the linear aspect is the same in both. Notice in the picture of artificial light how the window catches the reflection of the lantern and, because the lantern is at eye level, how the picture glass reflects the light. The leaves of the house-plant appear as silhouettes in daylight — in artificial light their shiny surfaces reflect it.

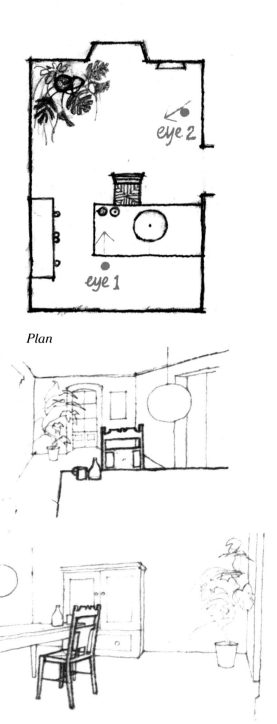

Plan

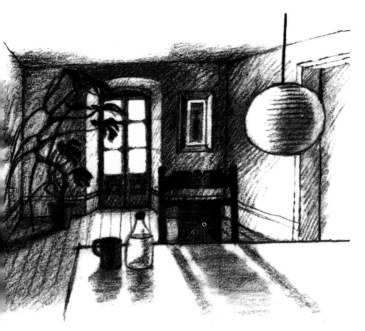

Drawing from eye position 1 with light source from window.

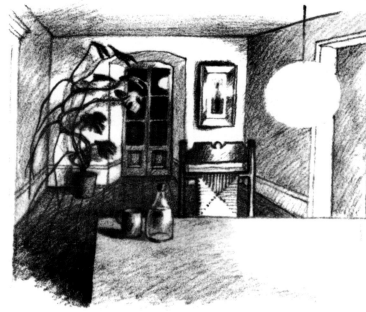

Drawing from eye position 1 with artificial light at night.

In the third illustration, on the left, we are looking at the same room but from eye position 2. Try making drawings of your own rooms, but keep detail to a minimum in order to concentrate on the tonal aspects, which the lighting provides, and use strong but simple shading. Naturally, sparsely furnished rooms are the best subjects on which to begin.

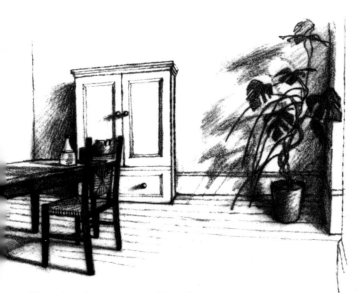

Drawing from eye position 2.

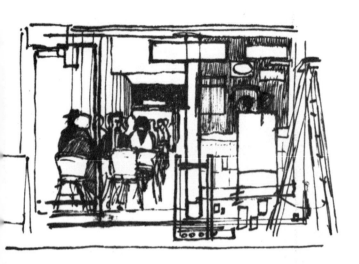

A quick fountain pen sketch of an interior seen from the exterior — a café interior seen through its plate-glass window. I made this sketch on a scrap of paper while waiting for a bus.

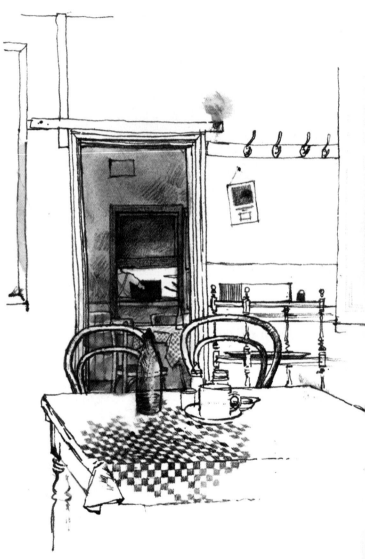

Kitchen, 2B pencil, black ink and ink washes on cartridge paper.

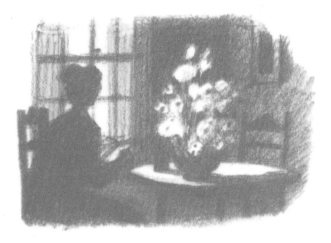

A tonal study in sepia conté shows dramatic use of silhouette with light falling across the table in front of the seated figure on to the table and the vase of flowers.

Dynamic use of line and tone

Let us now consider the inter-relationships of the various elements in drawing and how they contribute to the total effect. A simple example of this exists in the small sepia sketch, page 24, below left. I have taken both a dark and a light silhouette and combined them with a minimal amount of line. The figure and chair form the dark silhouette against a light window area whilst the flowers and table top form the light silhouette against the dark area of wall in shadow. This form of visual relationship, known as 'counter change', can be discovered continuously in nature and, of course, in the work of all artists.

A secondary silhouette is formed by the far chair and the pots on the table top. The whole composition is prevented from becoming too harsh and mechanical by the use of intermediate tone in the curtains, flowers and gradation of wall shading.

In the illustration on the right of page 24 the same 'counter change' exists but falls within itself: white wall with the dark silhouette of a large doorway which contains within it a further doorway beyond which a light silhouette frames further dark shapes. The table uses a pattern to contrast with the light wall areas, while a sauce bottle and mug offer a dark and light shape respectively. These dark and light areas can be organised by the artist without slavish reference to existing lighting conditions. However when we study the existing lighting in our subject we often find that it presents us with very rich examples of this phenomenon. Again, the overall effect is softened and helped to appear more natural by the use of line to define other items such as chairs, door-framing and tea trolley.

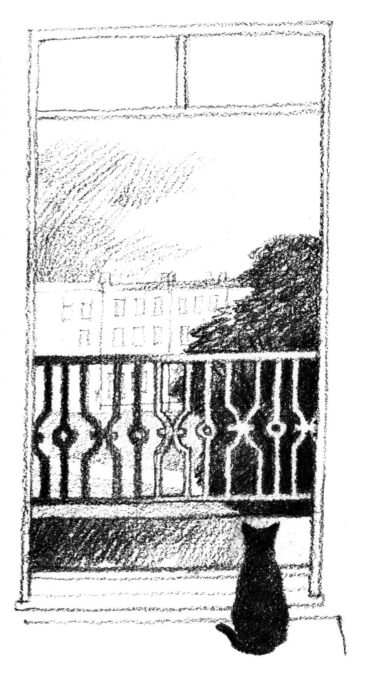

Cat at the window. *Notice how the balcony railings change from positive shapes (left) to negative ones (right) as the tonal background changes.*

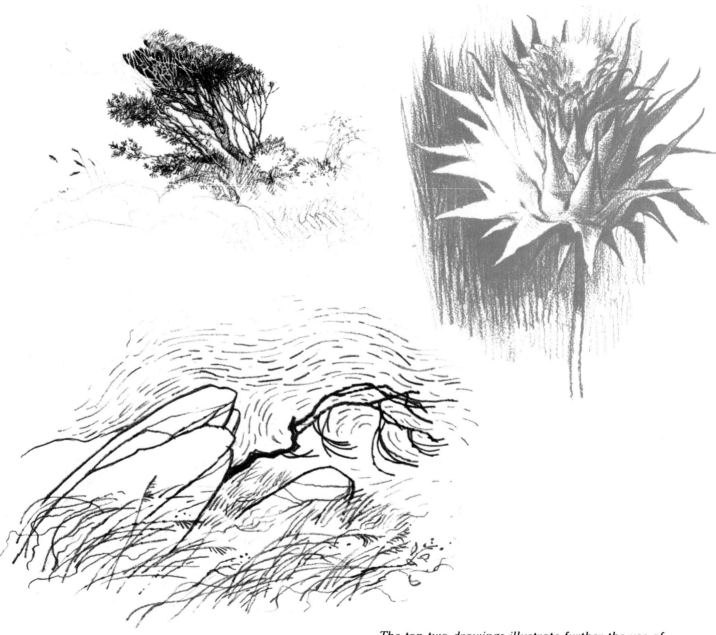

The top two drawings illustrate further the use of
negative and positive shapes to describe their subjects.
Left. *Mood can be expressed by making lines flow in
specific directions. Here the effect is bleak and
windswept.*

Sketching outdoors

One of the first habits you should cultivate when taking up drawing seriously is to carry around with you some sort of drawing material. Like the professional photographer who always carries a camera, so you must have in your handbag or coat pocket something to record what might catch your eye. Always have with you a small ringbound sketchpad and a couple of pencils. Felt pens are good for making lightning sketches — remember that, what you are after, most of the time, is *not* a finished drawing but a record. In the glove compartment of my car I always have my basic equipment — and my jacket pocket usually contains paper and pencils.

For serious sketching, more elaborate equipment may be useful, but only to the point of being portable. Many beginners carry around too much equipment, which encumbers them to the extent that they are never comfortable or easy. Think of yourself as being part of your equipment — if you cannot move from viewpoint to viewpoint with ease, or climb up rocks or squeeze yourself into a corner of a street, then there will be little use for your equipment, for what you see is the important thing; and the more mobile you are, the more you will see.

One problem that many beginners encounter, when faced with the panoramas that outdoor sketching provides, is that of selection of viewpoint and boundaries. As I have said, do not start sketching at once, but walk about, observe shapes and blocks, tones and lines. Some people find a simple viewfinder handy — most of you will be used to a camera viewfinder — so make one out of a stiff piece of card similar to the diagram on this page. This will both enable you to select that part of the panorama that you wish to depict, and tell you whether the composition is 'right'. Then make sure you are as comfortable as possible, and set to work! Remember, it is not so much the work itself as the more intense observation engendered by your activity that is of immediate and lasting value.

Another problem which beginners face is what to put in, and what to leave out? Townscapes often present a plethora of jumbled detail, confusion and repetition. Sort out in your mind's eye what contributes to your picture and what is superflouous, and concentrate on the former. The main thing is to depict the principal forms

and shapes accurately — detail can be added later.

When putting in detail you will find that many parts are repeated: windows, doors, mouldings, for example. It is only necessary to draw one or even a part, the others being indicated by outline. This saves time when working outdoors; the unfinished parts can be put in at home, but it is necessary to complete the work as soon as possible while the images remain strong and fresh in the memory.

Also, vary your use of media appropriately. A foreground object can be rendered simply and strongly with wax crayon or felt-tip pen and more distant parts and fine detail with a sharp pencil or fine pen. Diluted ink washes can block in shadow areas quite quickly.

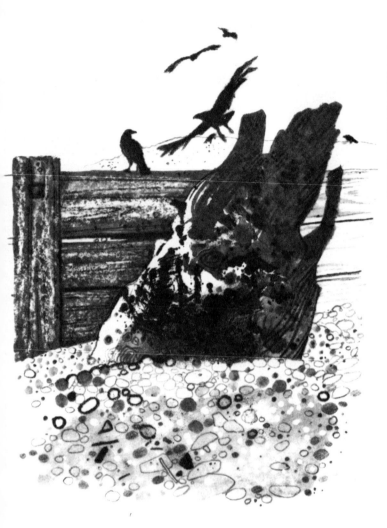

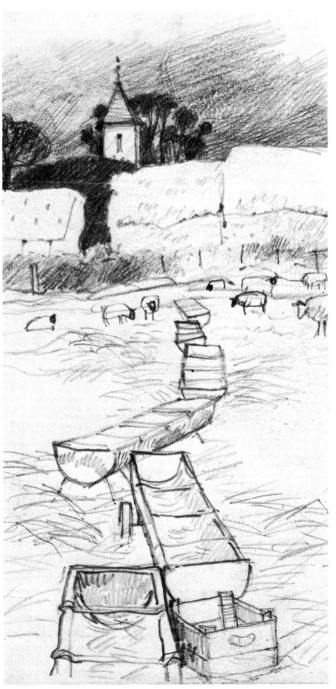

Seashore stump. *This sketch combines a variety of media: pencil, crayon, black fountain pen and ink washes. I worked over this drawing when I got home after recording in situ enough detail to remind me what I eventually wished to put down.*

Right. *The sheep troughs meandering across the field were the 'key' to this composition; I walked about the field until I found the most dramatic angle, which gave me a satisfactory T-shaped composition.*

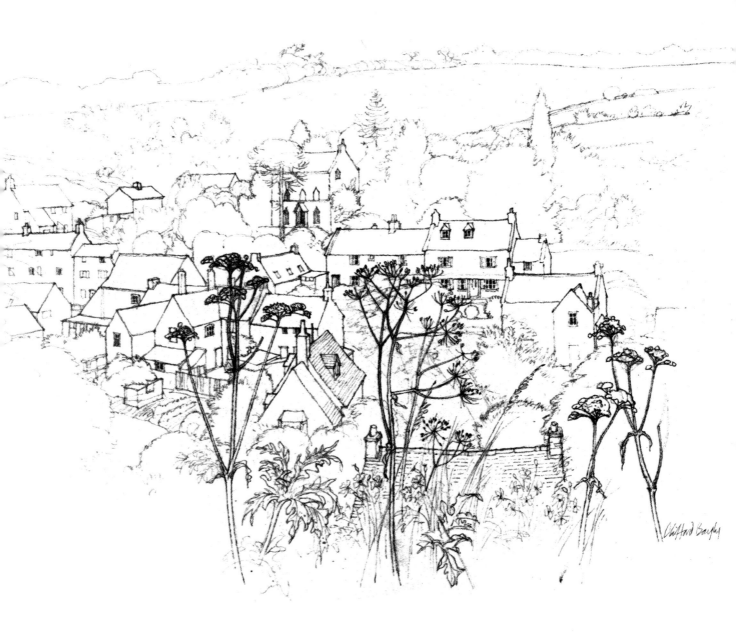

In this finished drawing I have used weight of line to create recession, the nearest objects carrying the darkest lines. When you have mastered tone, practise this kind of control leaving out blocked tone wherever possible.

Using a sketchbook

Sketchbooks are goldmines of information, expression and, above all, the most intimate insight into the way artists work; for they embody their own personal short-hand of the way they see the world about them.

I use my own sketchbook in a wide variety of ways, but principally for quick studies: people, animals, places, details, and occasionally for more extended and careful drawings. I also put down colour notes, textures and make rubbings with wax crayon on textural surfaces that interest me.

When drawing people I like to be as unobtrusive as possible so that I can observe them unawares; drawing the way they hold things, their reactions to odd happen-ings — sudden showers, a loud noise in the street.

The landscapes that interest me most are those that bear the impact of man's influence: tracks, ploughed fields, roads and buildings in cities, signs and lettering on shop fronts — all catch my eye, as does the activity in street markets and people at work anywhere. I look for the unusual amongst the familiar and vice versa.

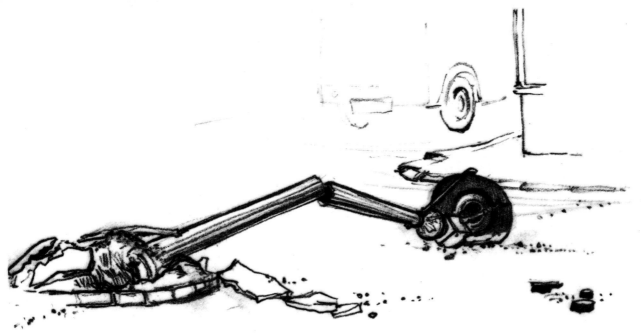

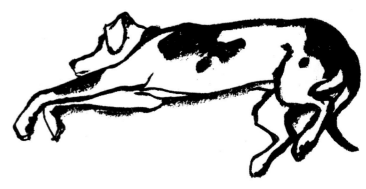

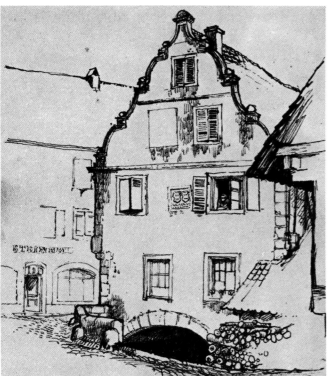

The drawings and sketches on these two pages are all taken from my sketchbooks and were done over a period of years. As you will see, they are executed in different media: pencil, sepia conté, pen and ink; the drawing of my dog asleep in front of my fireplace was drawn with a brush and Indian ink. Never forget to take your sketchbook on holiday; the barn and the old house over a culvert were drawn when I was travelling in Europe.

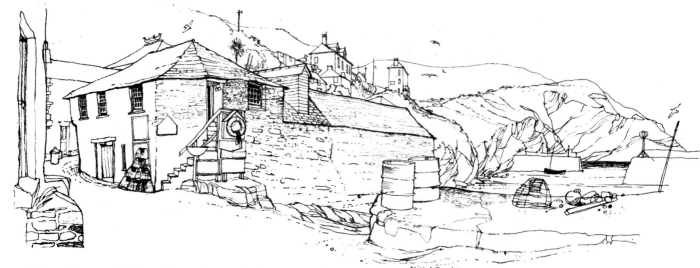

A West Country fishing village, drawn in fine pen and ink. Notice how I tucked myself in close to the wall; by drawing just part of the cottage I lead the observer 'round the corner' of the road, which disappears over the hill through the houses in the middle distance. Such hints add to the interest of your drawings.

First published 1986
Search Press Limited
Wellwood, North Farm Road,
Tunbridge Wells, Kent TN2 3DR

8th impression 1993

Text and illustrations by CLIFFORD BAYLY

Material from this volume, text and illustrations, has previously been published in *Drawing for Pleasure* (1983), edited by Peter D. Johnson and published by Search Press Ltd

ISBN 0 85532 570 4

Printed in Spain by Elkar, S. Coop. - 48012 Bilbao

Distributors to the art trade:

UK

Winsor & Newton,
Whitefriars Avenue, Wealdstone,
Harrow, Middlesex HA3 5RH

USA

ColArt Americas Inc.,
11 Constitution Avenue, P.O. Box 1396, Piscataway, NJ 08855–1396

Arthur Schwartz & Co.,
234 Meads Mountain Road, Woodstock, NY 12498

Canada

Anthes Universal Limited,
341 Heart Lake Road South, Brampton, Ontario L6W 3K8

Australia

Max A. Harrell,
P.O. Box 92, Burnley, Victoria 3121

Jasco Pty Limited,
937–941 Victoria Road, West Ryde, N.S.W. 2114

New Zealand

Caldwell Wholesale Limited,
Wellington and Auckland

South Africa

Ashley & Radmore (Pty) Limited,
P.O. Box 2794, Johannesburg 2000

Trade Winds Press (Pty) Limited,
P.O. Box 20194, Durban North 4016